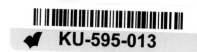
PRUNELLA CLOUGH

50 Years of Making Art

28 January - 21 March 2009

Annely Juda Fine Art

23 Dering Street (off New Bond Street)
London W1S 1AW
ajfa@annelyjudafineart.co.uk
www.annelyjudafineart.co.uk
Tel 020 7629 7578 Fax 020 7491 2139
Monday - Friday 10 - 6 Saturday 11 - 5

Cover: **Lorry and Buildings: Study** 1952 oil on canvas 53 x 53 cm

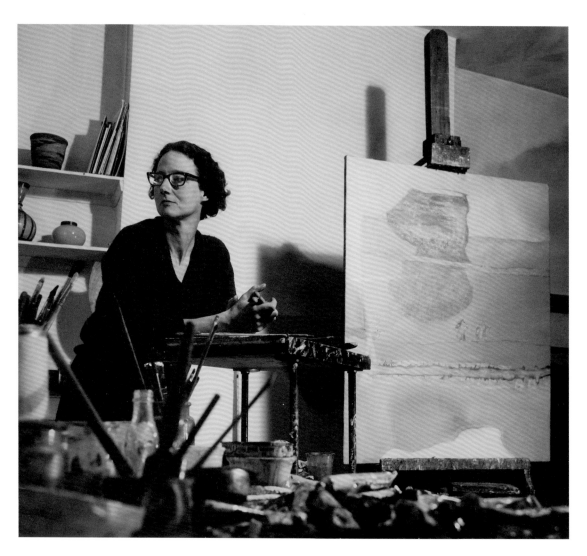

Prunella Clough in her studio

We have exhibited Prunella's work for the last twenty years, ten of which followed her death in 1999. After her Tate Britain exhibition in 2007 which toured to Norwich Castle Museum and Abbot Hall in Kendal, we continued the research into the works belonging to her Estate. We were surprised and excited to find not just works that we knew but also early and late paintings, reliefs and drawings that had probably never been exhibited before and soon realised that we had the basis of a wonderful retrospective exhibition spanning fifty years.

I would particularly like to thank the Estate: Hannah, Nick and Sophie Collins who have helped in every stage of making this exhibition. I would also like to thank Mel Gooding who has written such a perceptive introduction to this catalogue.

Prunella was not just a great artist but was also a wonderful person. Making Art was what was important to her and this is what this exhibition conveys.

David Juda

Prunella Clough: The Poetry of Painting

'Poetry endows things with a circumstantial life.' G. Braque

When Prunella Clough matured as an artist in the late 1940s, paintings of the industrial scene, rural and urban, of street, dockside, factory, fishing quay and farm, tended to concentrate either on the opportunities they afforded for abstract dynamics symbolic of the energies of 'modern life' or on the worthy documentation of the worker, farmer, fisherman as emblematic of human dignity and honest toil. And among many of her most adventurous and successful immediate predecessors and contemporaries in British art – Sutherland, Bacon, Piper, Paul Nash, Moore – there prevailed a theatrical romanticism, an over-wrought tendency to the pathetic fallacy, to dramatised emotion or mythopoeia. But once she had hit form, Prunella Clough went her own tough sweet way, and there is an underlying consistency, a continuous coherence of vision, from the generally monochromatic 'realist' paintings of her first decade through to the most fanciful and mysterious of her beautiful late paintings.

Prunella Clough seemed incapable of making an image that was not remarkable for its utter singularity. You look at a painting, a drawing, a print, a construction, and remark immediately an odd strangeness, a quirky reality. It may be that in certain respects it seems quite unlike any other image you have seen, by Prunella Clough herself or anybody else, but that it is nevertheless in some indefinable way quite *like* some thing or other that you have seen. Indeed it may give you an eerie sense of familiarity, as with something not closely observed or carefully considered, something not 'seen' as we go our way, but glimpsed, rather, somewhere out of the corner of the eye or caught in a passing glance. This corresponds, in fact, to the reality of a great deal of our everyday visual experience, for we look at the world with intently selective vision, and it takes a particular effort, or a deliberate relaxation of attention, to see what does not relate to our immediate purpose.

It is easy to underestimate just how radical a project it is for a representational artist to eliminate the selective focus of conventional figurative, landscape or still life painting. If these genres are typically preoccupied with figure-ground relations and the creation of pictorial space it is because they are concerned to picture the world as does the purposive eye, separating the significant object from the space and light that envelopes it. They present their subjects, figure or object, with emphatic deliberation. It is Clough's idiosyncratic shift of visual emphasis from the significant to the insignificant that characterises her distinctive vision.

In the early paintings we see this remarkable shift of perception occurring: in *Man with Printing Press* (cat. no. 14), *Man with Goggles* (cat. no. 13), *Factory Interior* (cat. no. 12), *Corrugated Fence* (cat. no. 16) for examples, it is not the human figures, the machines, or the industrial structures that are singled out, so to speak, so much as that each element in the scene is part of a complete image which combines it with all of the others. The image is determined by the poetic interlock of near and far, of foreground and background, of object and space, of human and mechanical: a creative integration made *in the act of painting* which endows every aspect of the given with an individual actuality within a greater reality proposed by the painting itself.

In those paintings we do not so much look at things as past them, through them, over them, between them to other things in another space. Fictional space and objective surface, pictorial

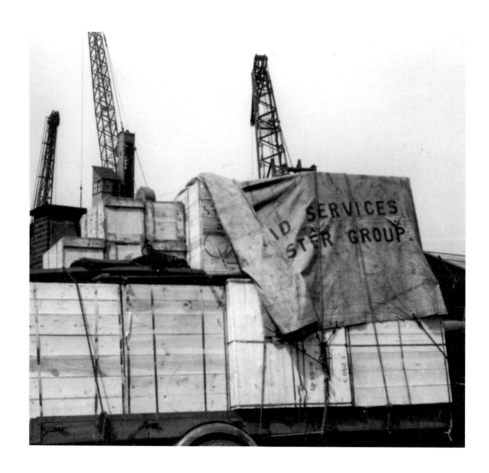

Source photograph
Prunella called these her rough photographs. She kept them as an aide-mémoire for visual events and combinations that interested her. They were never used directly.

recession and the plane of the support are identified, and human figures and heads are identified in equality with the objects and structures with which, in a moment's glimpse, they share shape or configuration. In later works this play between pictorial space and object or evocative surface is freer, unconstrained by any requirement of reference or representation, logical or otherwise: it is enough to be reminded of something, to recognise a similarity to something remembered or half-remembered, to take pleasure in the poetry that endows things with a circumstantial life.

In conventional genre landscape and domestic still life painting the humble subjects and objects, labourers, tractors, sheds, knives and forks, potatoes, saucepans are given salience; it is their moment on stage, to be granted the significance that is the largess of the painter. In Prunella Clough's paintings what is 'figured' – *intimated* might be a better word – is arbitrary and inconsequential except insofar as it is a moment of the irreducible actual, an unconsidered piece of reality: a corrugated fence that blocks a view, the gritty soil of ruined industrial waste-ground, machine scrap, a splash, a fenced-off moment of autumn. 'Reality', wrote Braque, 'only reveals itself when it is illuminated by a ray of poetry.' He added: 'All around us is asleep.' Prunella Clough's gift to reality is to reveal it, to bring it to waking.

In her later work these poetic intimations of reality might be no more than an unexpected shadow or a fall of light, a passing cloud, a crinkled sweet-paper, the gaudy brilliance of a child's trinket, a curve of a hill over a distant building, a patch of grass, a fragment of leaf or flower, the tracks of raindrops down a window pane that draw the outline of a tree, a discarded typewriter ribbon (but look! crumpled into the shape of a dancer!), a spectrum-scintillation of an oil slick on a puddle, a tangle of wire. Prunella Clough partakes of the capacity of the world itself to present us with never-ending surprise, to show us again and again something different and new in the known and familiar, requiring nothing more than the tilt or turn of the head, the narrowing of the eyes, the close-up approach to an object or a surface, the obscuring half-light of dusk and the slow brightening of dawn.

That shift of visual emphasis which I have already described was two-fold: from the recognisable subject to an unfamiliar aspect of it, vividly evoked; and from a visual rendition to an atmospheric one, which is to say, from observation to recollection in its deepest and most complex definition: '… it is the memory or recollection of a scene, *which is also a whole event*, that concerns me. A painting is made of many such events, rather than one…' She was concerned, then, not only with the way things look but also with the many ways in which things seen or half-seen enter the mind and thence the memory, and are there combined and transformed to become an active agency in our everyday apprehension of the world. Her art enacted the truth of the old American catch-word: 'Nothing is lost.'

Prunella Clough looked at the urban and industrial world with a vigorous and unsentimental curiosity. But it was always with that almost instinctive tendency to see it slightly askew, to avoid the obvious, to catch at the unconsidered aspect, to find in it something normally un-observed. I say '*almost* instinctive', because as her notes on both her sources and her paintings (and her marvellous photographs) reveal, it was also in her nature to observe concrete particularities with a concentrated artistic – or poetic – purpose, conscious of the use she might make of them in the studio. 'Anything that the eye or the mind's eye sees with intensity and excitement will do for a start… it is the nature and structure of an object – that, and seeing it as if it *were strange and unfamiliar*, which is my chief concern.'

Source photograph

In seeing real things thus fresh and new, she drew on broad knowledge and deep understanding of both historical and contemporary painting. Clough was self-consciously aware of both tradition and innovation in art. What may appear at first sight idiosyncratic in her practice is the outcome of a knowing and subtly intelligent assimilation of pictorial device from many sources. Above all, as her friend Patrick Heron observed with characteristic vehemence, she had 'profound affinities with the visual culture of Paris. It was always French, not English, examples that intuitive apprehension of those submerged formal rhythms which have governed the dispositional unities of her paintings (in other words, which have determined her compositional habits).'

If post-war French abstraction (in all its manifestations) largely shaped her sense of the relations on the canvas plane of one item to another (and here I agree completely with Heron), there were other important affinities and recognitions at work. The unexpected angles of view in the early work, and the integration of working man into his industrial setting, she explicitly related to *trecento* and *quattrocento* Italian townscapes. In her use of diverse materials and surface textures she drew upon contemporary developments of collage, assemblage, on the urban matter of the French *l'art autre*, on *Tachisme*, and on the 'poor materials' and of Burri and *arte povera*. As for the pervading oddness and arbitrariness of her subjects, her disconcerting juxtapositions of disparate motifs, and her incongruous introductions of prismatic and artificial colours, these she most surely derived from an unassuming and largely un-remarked (by her or anyone else) cultivation of Surrealist imaginative procedures.

When I referred to her 'marvellous' photographs – of tangled wires, ropes and netting, factory gates, cranes, discarded gloves – I had in mind André Breton's magisterial dictum: '... the Marvellous is always beautiful, everything marvellous is beautiful. Nothing but the Marvellous is beautiful.' As Breton (and his Surrealist colleagues) knew, the marvellous may be found in the inconsequential, a lost glove, a stain on a wall. I remember also, as relevant, her affection and admiration for her close friend, the sometime surrealist sculptor F.E. McWilliam, who shared with her a creative predilection for the discarded and the disregarded, seeing in unconsidered objects and banal things opportunities for mysterious poetic transformations. Clough's images, in whatever media, are, like those of Surrealism, of a kind that affects and inflects the way we look at ordinary things, and induces us to discover strangeness and beauty in the familiar.

The resonance of these poetic realisations had much to do with Clough's extreme diffidence and modesty as a person. She had a certain quietness of spirit that brought with it an extraordinary receptivity, a quality of critically uncluttered apprehension described by Keats as '*Negative Capability*': 'that is, when a man is capable of being in uncertainties, Mysteries, doubts, without an irritable reaching after fact and reason...' Together with this she was gifted with a rare intentness of regard, a sympathetic insight into the quickness and quiddity of things which reminds me of something else Keats wrote: '... nothing startles me beyond the moment. The setting sun will always set me to rights – or if a Sparrow come before my Window I take part in its existence and pick about the Gravel.' The greatest poetry is made from such precise and empathetic acuity of perception, such alertness of intelligence.

Mel Gooding, November 2008

1 **Red Mullet** 1943
 oil on canvas
 25.5 x 35.5 cm

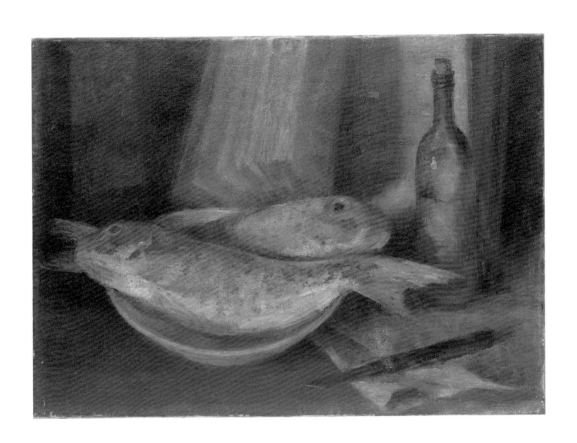

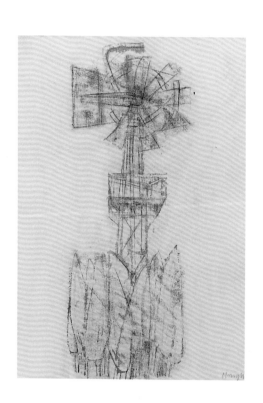

2 **Windmill and Reeds** 1940s
chalk and wash on paper
28 x 19.5 cm

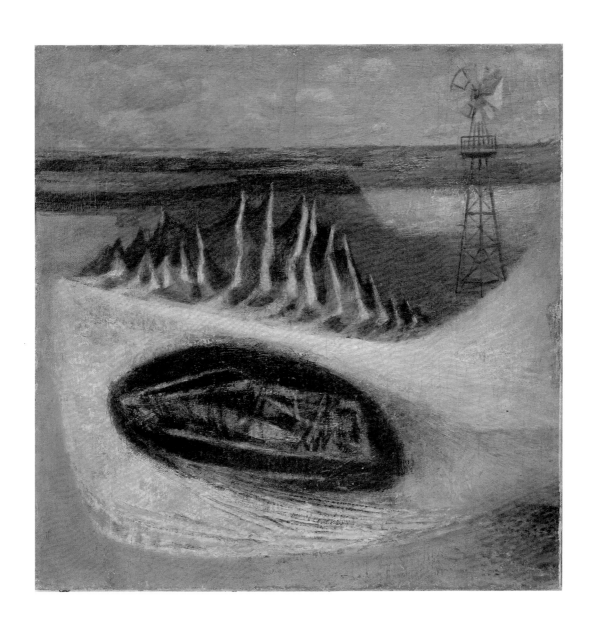

3 **Untitled** 1940s
 oil on canvas
 51 x 51 cm

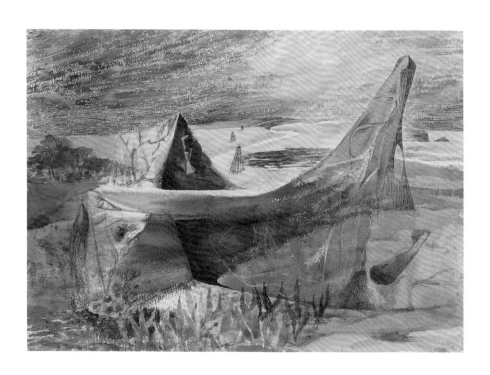

4 **Untitled – Landscape** c.1940s
pen, ink, wash, watercolour and crayon on paper
25.3 x 35.4 cm

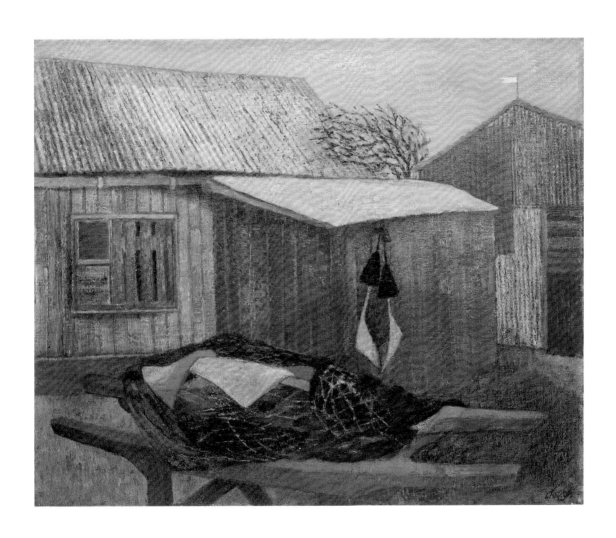

5 **Sheds** 1945
 oil on canvas
 50 x 61 cm

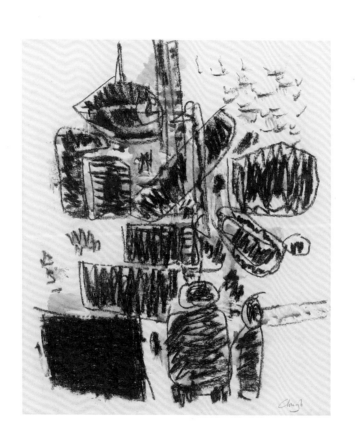

6 **Men by Cranes** 1956
 chalk and wash on paper
 45 x 40.3 cm

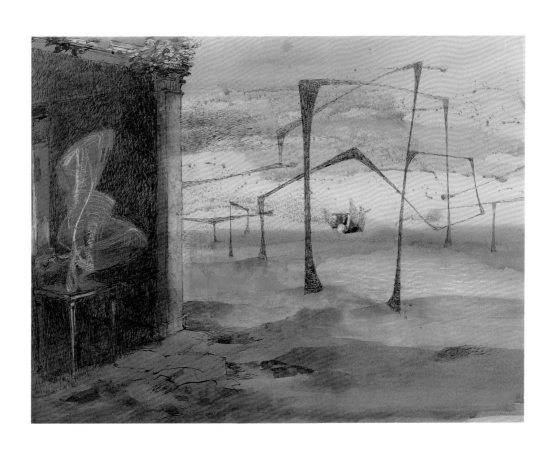

7 **Untitled – Surrealist Landscape** c.1940s
pen, ink and wash on paper
28.7 x 38.3 cm

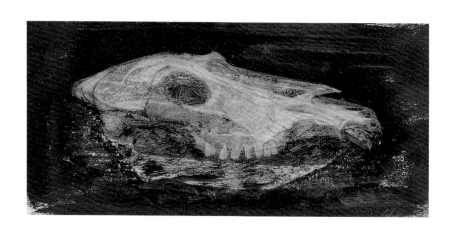

8 **Horse Skull** 1946
watercolour, crayon and pastel on paper
7 x 15 cm

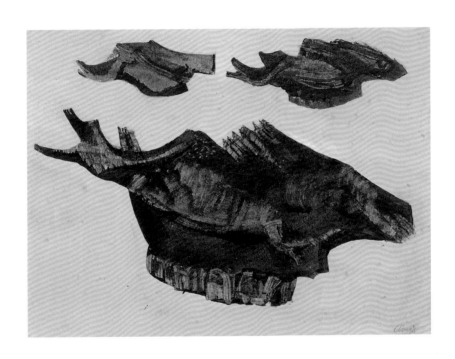

9 **Skull Bone: Study** 1947
gouache and watercolour on paper
23 x 31.2 cm

10 **Boy Drawing (David Haughton)** 1948
oil on board
32.7 x 35.4 cm

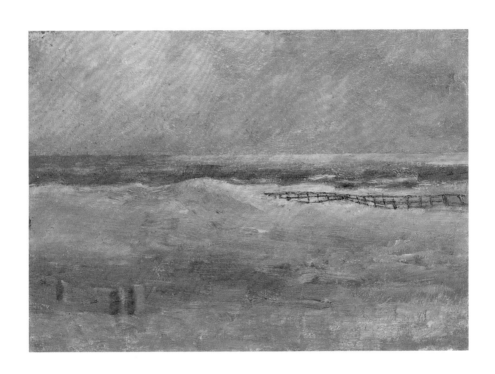

11 **Study for Scene on Ruined Beach** 1944
 oil on board
 17.6 x 25.3 cm

12 **Factory Interior (Wool Carding Shop)** 1954
oil on canvas
90 x 51 cm

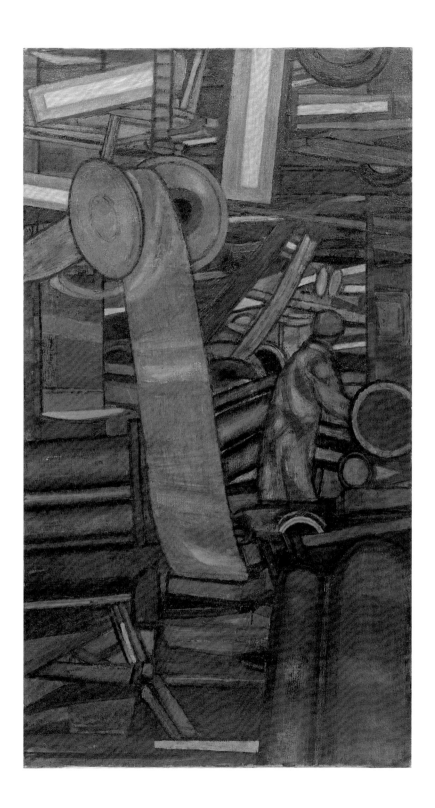

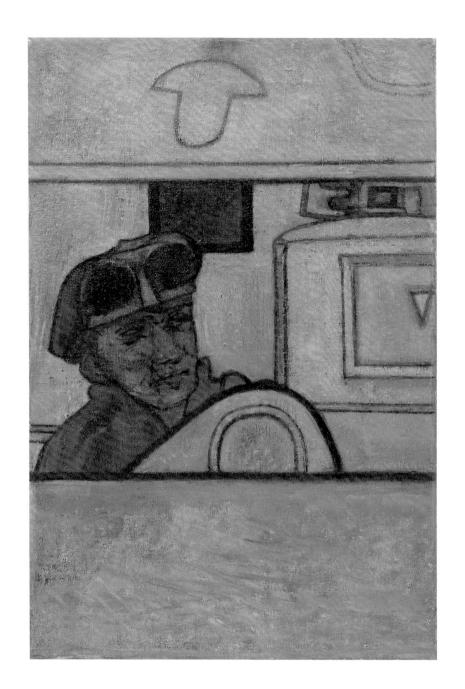

13 **Man with Goggles** 1956
oil on canvas
56 x 38 cm

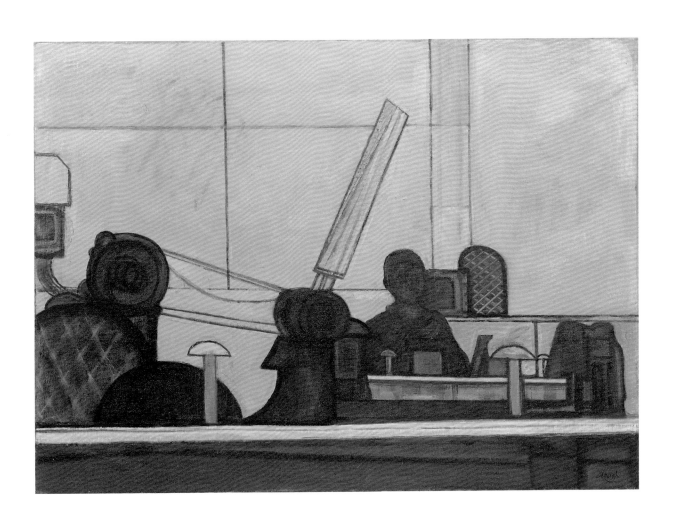

14 **Man with Printing Press** 1953
oil on canvas
56 x 76 cm

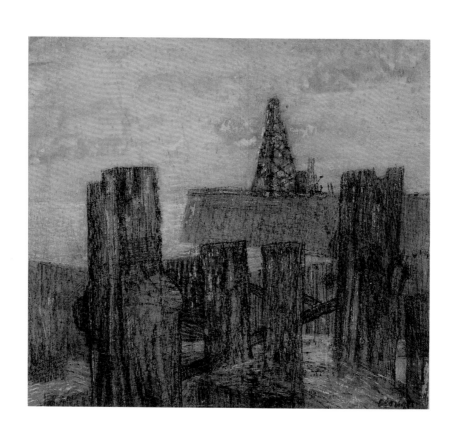

15 **Pier and Pile Driver** early 1950s
mixed media on card
24 x 26.8 cm

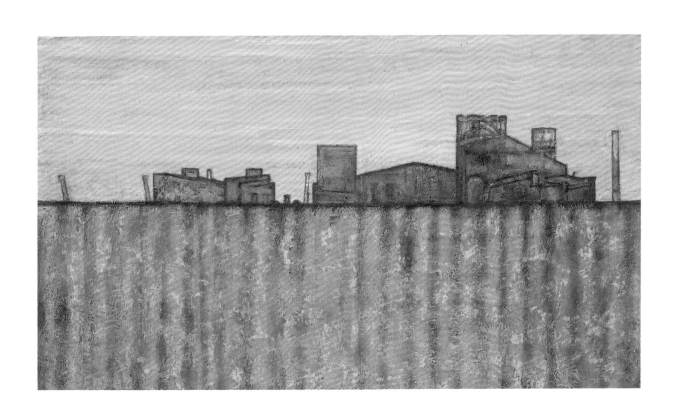

16 **Corrugated Fence** 1955
oil on board
53 x 92.5 cm

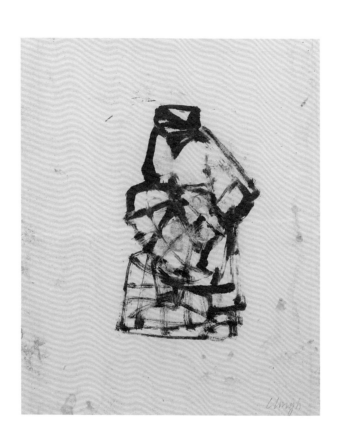

17 **Man with Lobster Pots** c.1950
ink on paper
21.5 x 16.5 cm

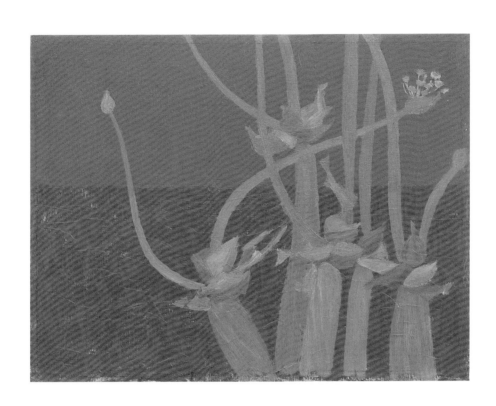

18 **Onion Flowers** 1947
oil on board
18.7 x 24.8 cm

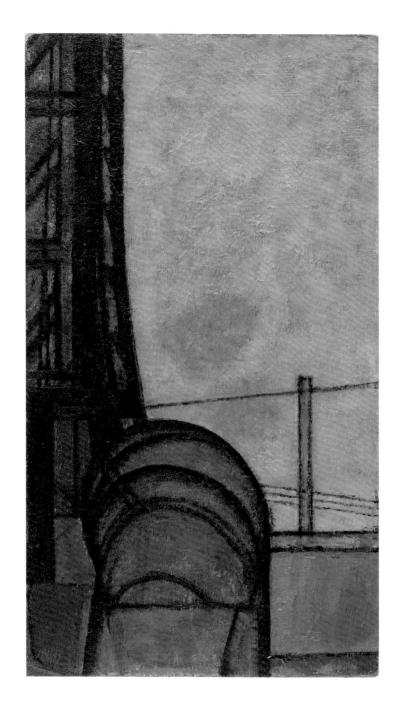

19 **Untitled** early 1950s
oil on board
53 x 30.5 cm

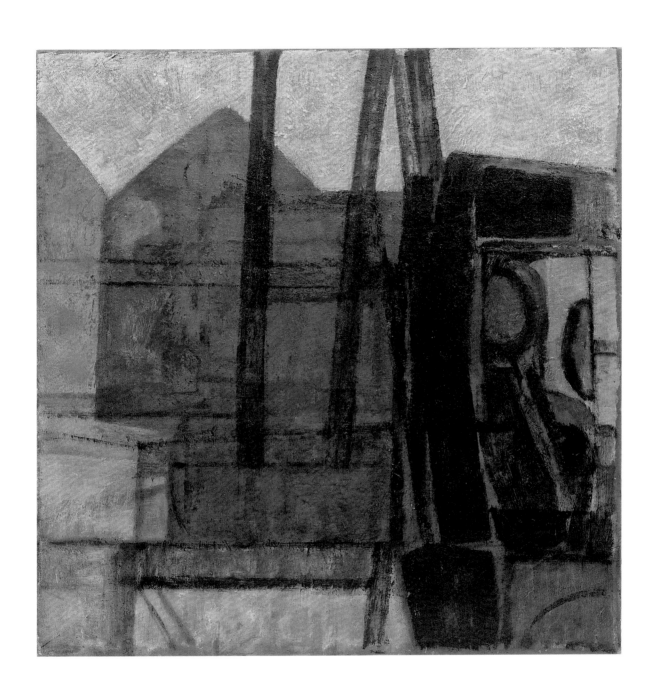

20 **Lorry and Buildings: Study** 1952
oil on canvas
53 x 53 cm

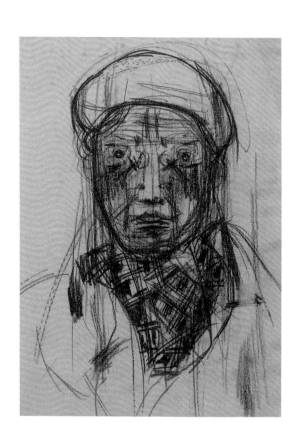

21 **Study for Factory Worker** c.1953
charcoal on paper
36 x 25 cm

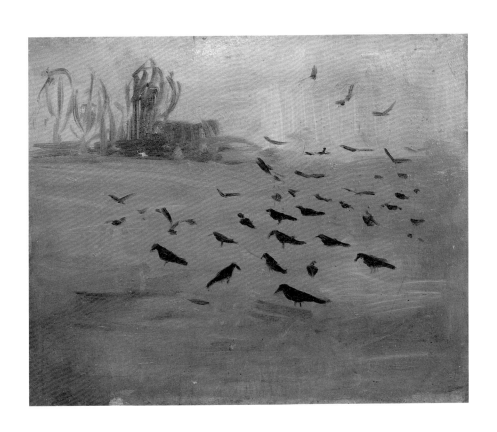

22 **E.B.S. Rooks** mid 1950s
oil on board
22.6 x 27.7 cm

23 **Untitled** 1950s
 oil on board
 20.2 x 15.2 cm

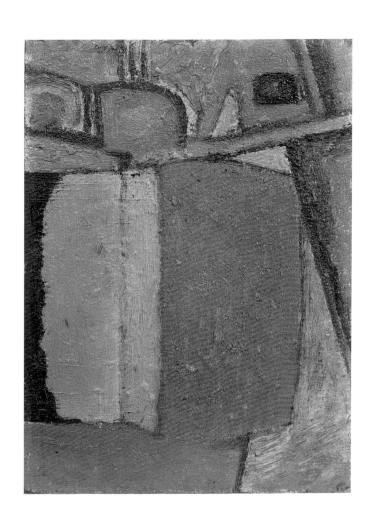

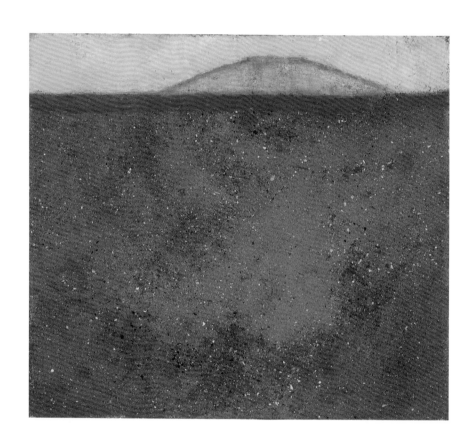

24 **Slag Heap** 1958
mixed media on board
27.7 x 31.3 cm

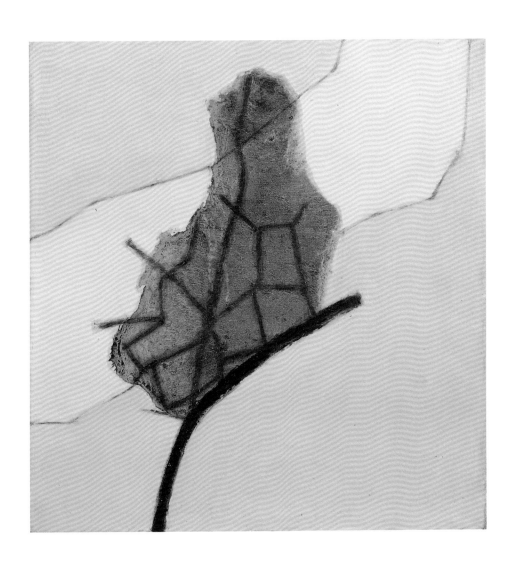

25 **Untitled** 1967
oil on canvas
42.5 x 40.5 cm

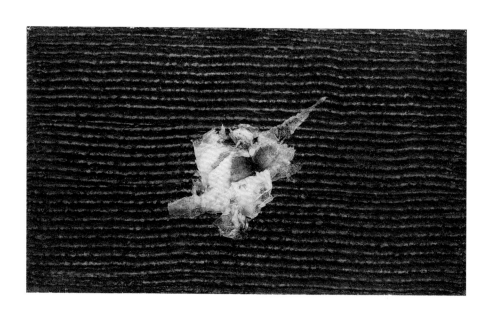

26 **Untitled** c.1990s
painted tissue paper on board
19 x 33 x 0.5 cm

27 **Untitled** 1965
wood and metal on board
26.8 x 25 x 1.5 cm

28 **Untitled** c.1980s
oil on canvas
102 x 97 cm

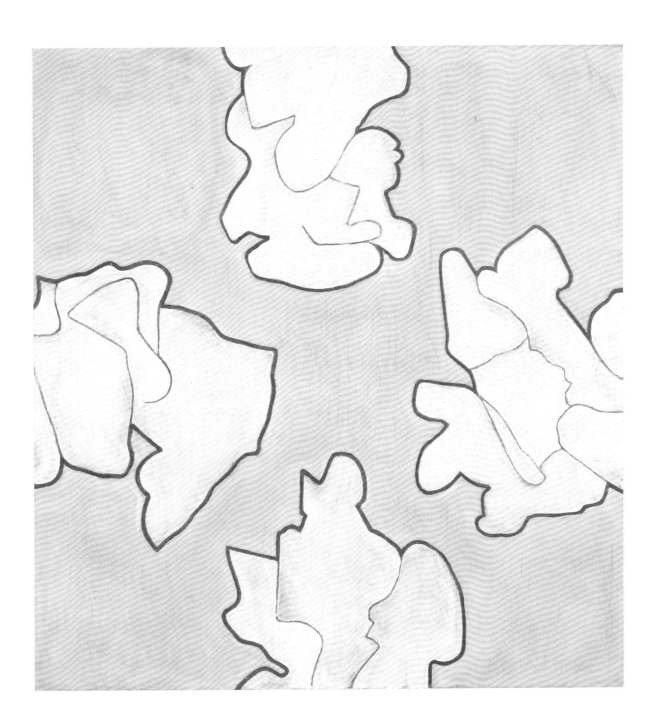

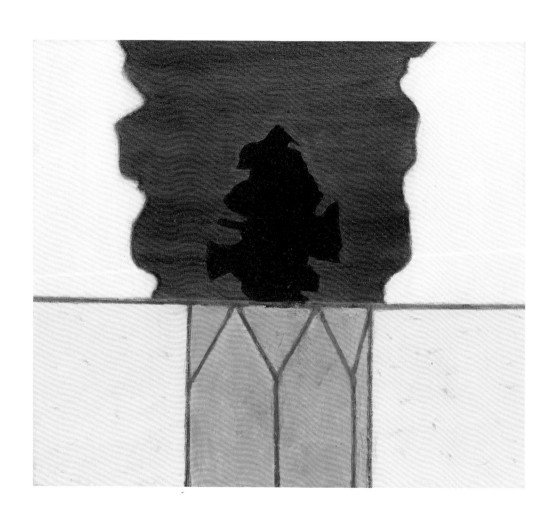

29 **Autumn Garden** 1964
oil on canvas
40 x 46 cm

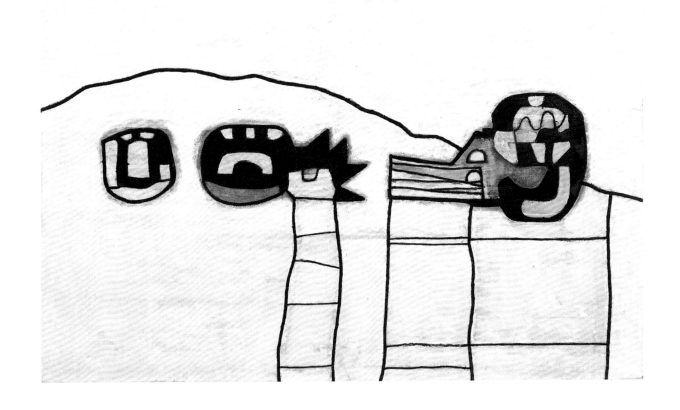

30 **Machine Scrap** 1966
oil on canvas
46 x 71 cm

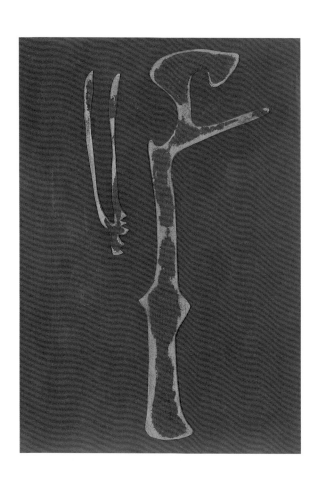

31 **Rain/ Tree/ Window** 1978
painted cardboard relief
41 x 28.5 cm

32 **Rain/Tree/Window** 1978
painted hardwood relief
64.5 x 61 x 2.3 cm

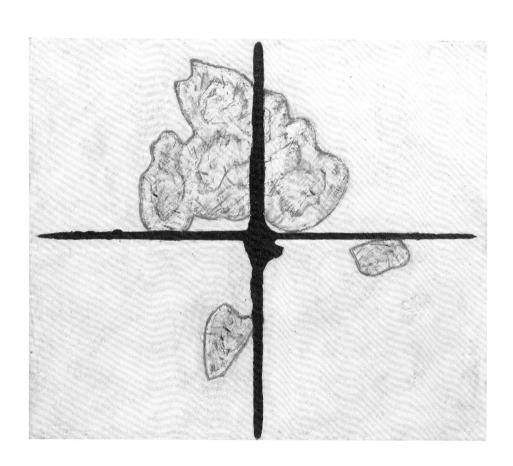

33 **Red Quadrant** 1973
oil on canvas
38.5 x 46 cm

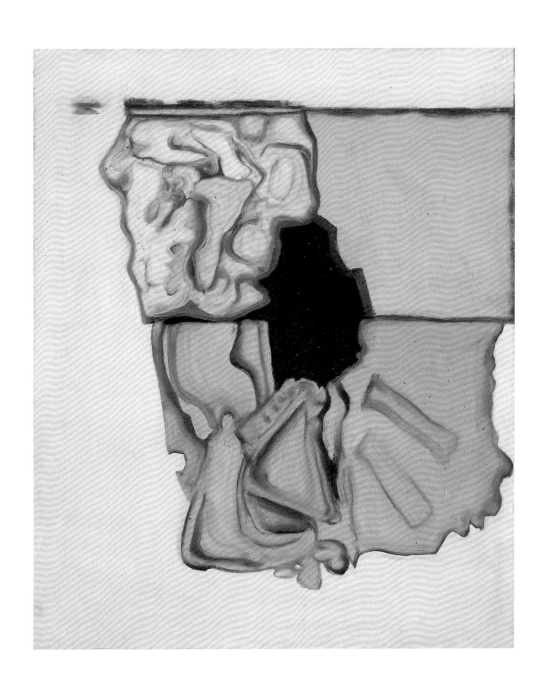

34 **Detail** 1966
oil on canvas
61 x 50.5 cm

35 **Untitled** 1984
oil on canvas
76 x 63 cm

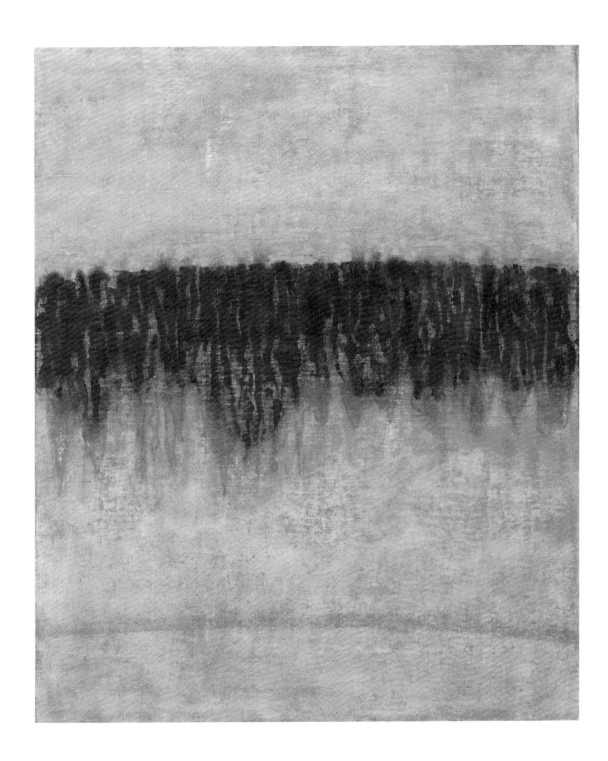

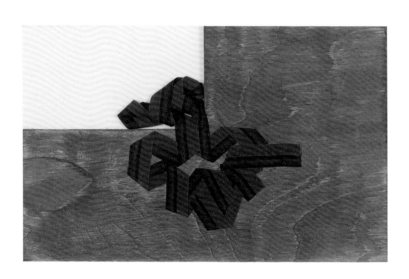

36 **Red and Black** 1974
typewriter ribbon and wood
15.1 x 23.9 x 2 cm

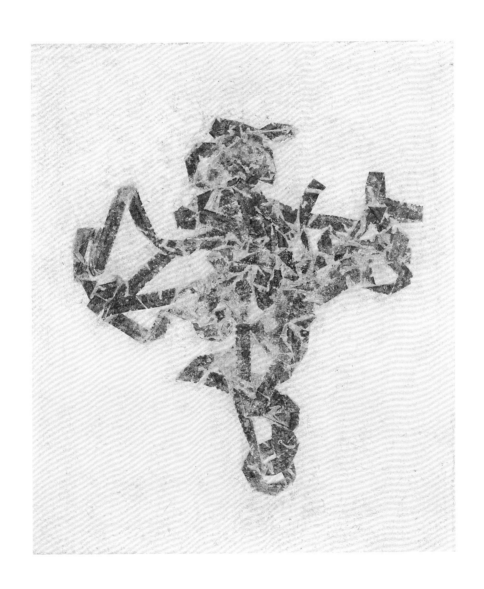

37 **Dancer** 1974
typewriter ribbon on board
44.5 x 38.5 cm

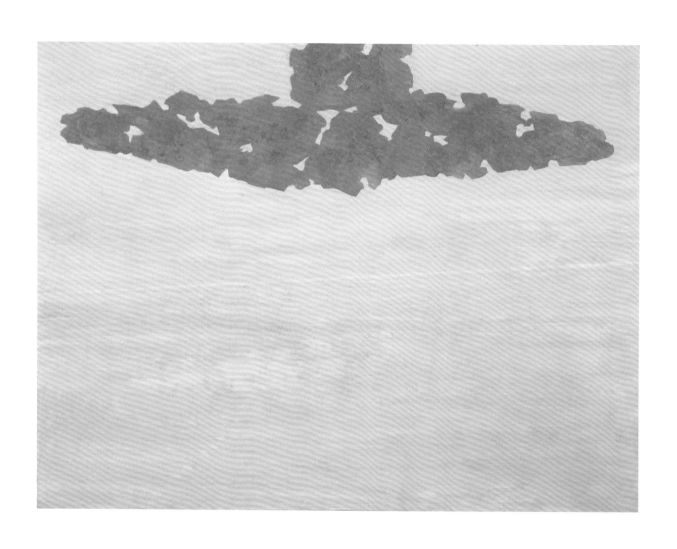

38 **Untitled** c.1980s
oil on canvas
114 x 152.5 cm

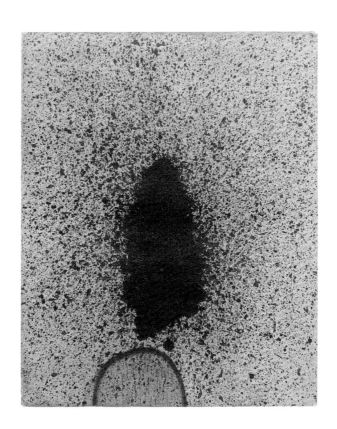

39 **Splash** 1970s
oil on canvas
38.3 x 31.5 cm

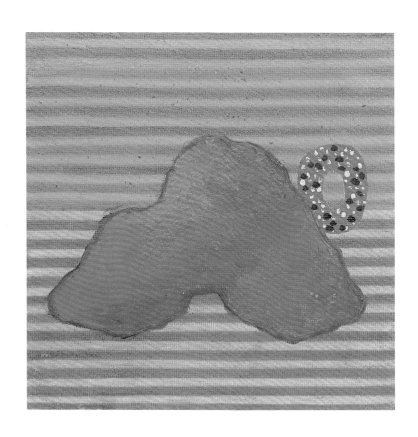

40 **Untitled** c.1990s
 oil on board
 31 x 32 cm

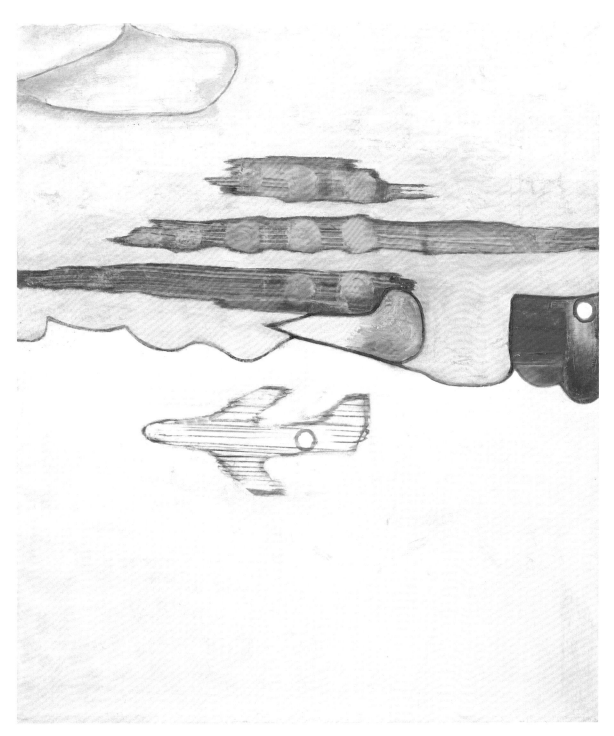

41　**Flight Path**　c.1980s
oil on canvas
115 x 99 cm

42 **Grass Plot** 1988
 oil on canvas
 82 x 54 cm

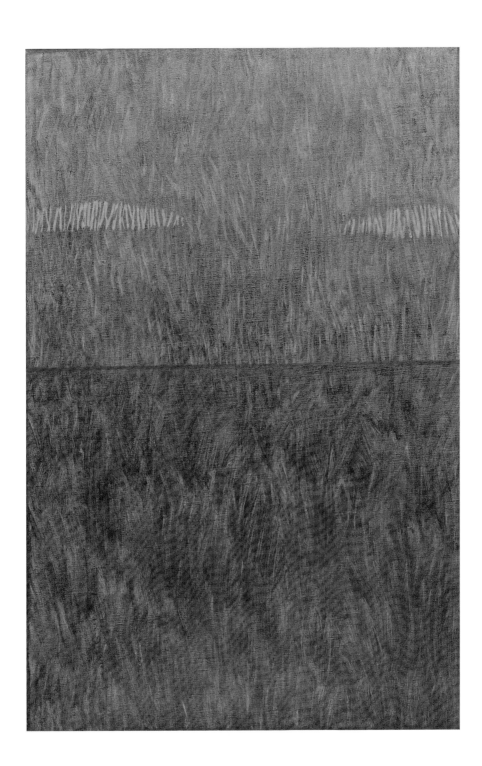

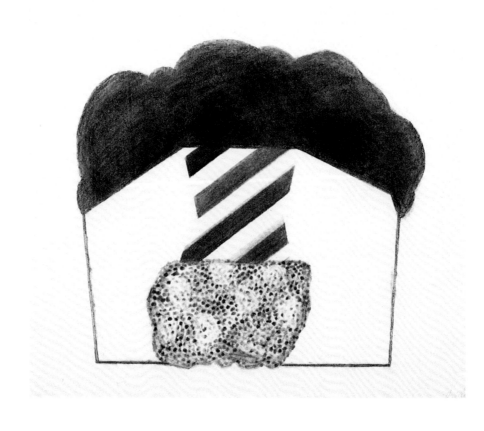

43 **Under the Bridge** 1979
charcoal on paper
53.6 x 56.5 cm

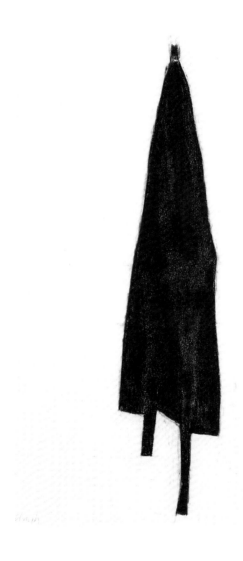

44 **Dressing Gown** 1989
charcoal on paper
48 x 33 cm

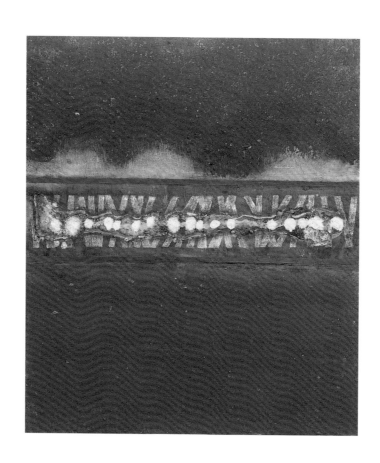

45 **Pennants** 1997
oil on board
29 x 25.5 cm

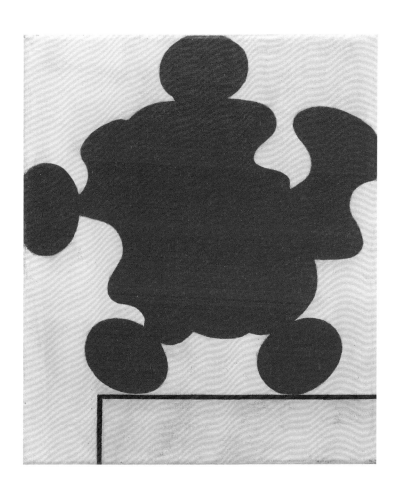

46 **Toy** 1980s
oil on canvas
35.7 x 30.7 cm

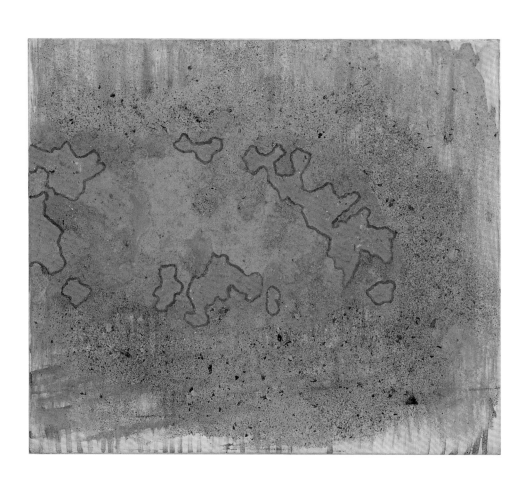

47 **Scrub Fire** 1986
 oil and sand on canvas
 42 x 48 cm

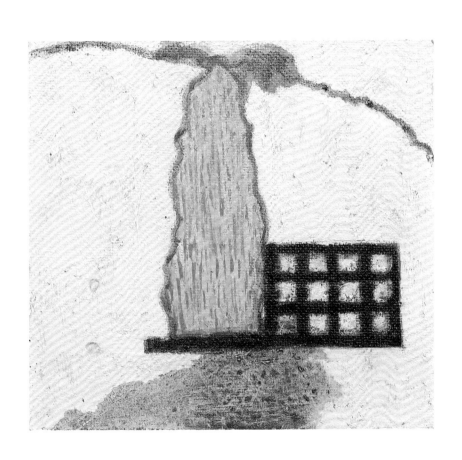

48 **Place Revisited** 1985
oil on board
21.5 x 23 cm

49 **Prize 2** 1997
 oil on canvas
 99 x 114 cm

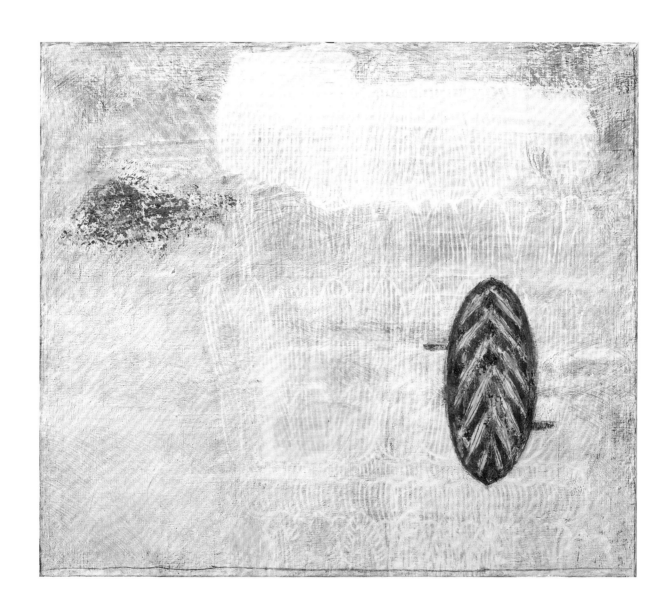

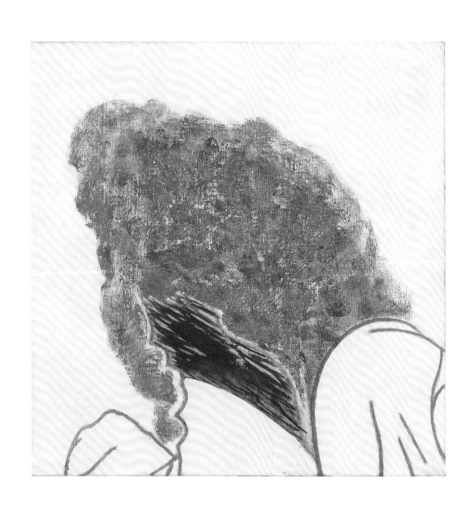

50 **Exh. Floral** c.1980s
oil on canvas
40.5 x 40.5 cm

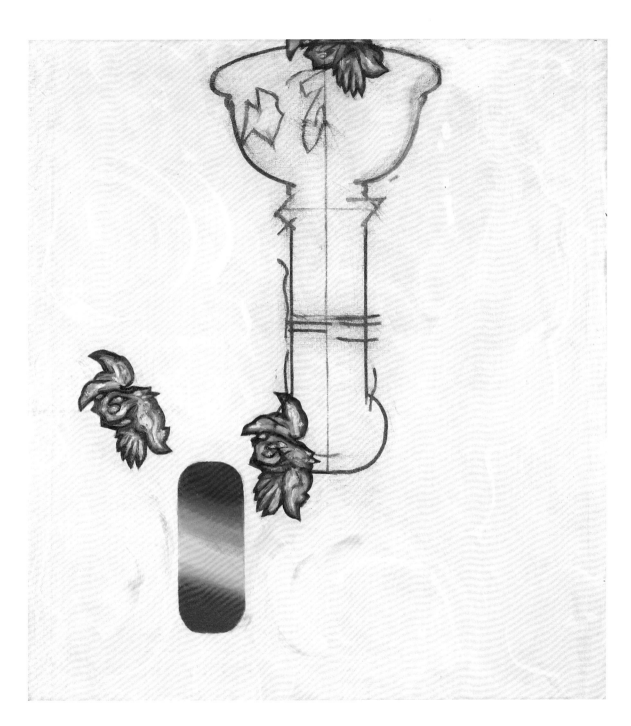

51 **Prize 1** 1997
 oil on canvas
 81 x 74 cm

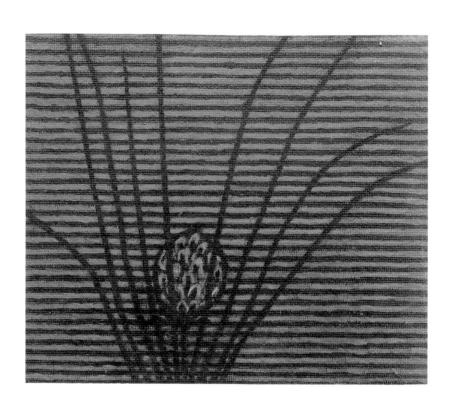

52 **Artificial Flower** 1994
 oil on board
 26 x 31.5 cm

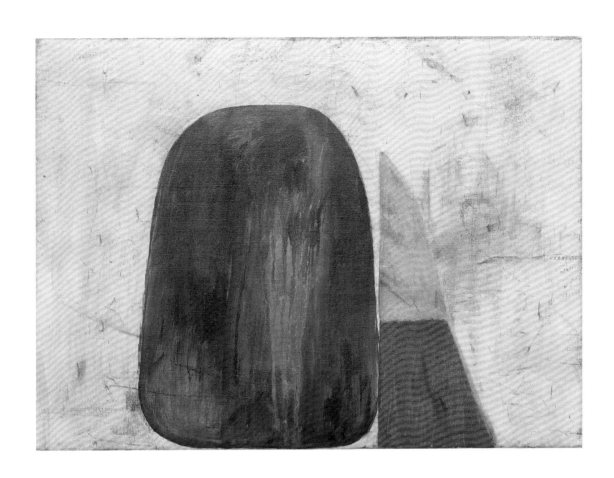

53 **Array** 1986
 oil on canvas
 44 x 61 cm

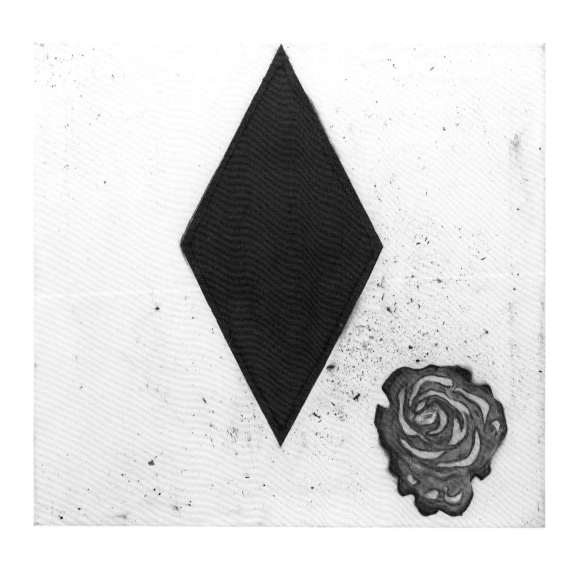

54 **Ceramic Rose** 1996
oil on canvas
51 x 56 cm

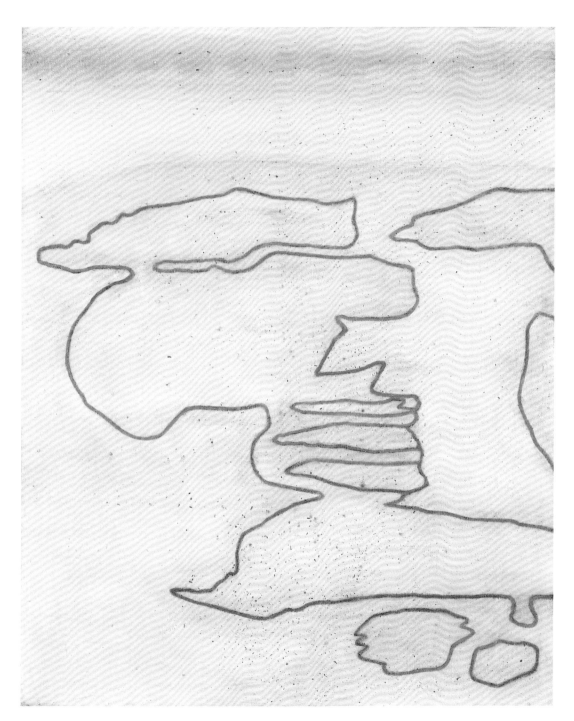

55 **Estuary 3** 1986
oil on canvas
79 x 64 cm

56 **Floating World** 1995
oil on canvas
73 x 53 cm

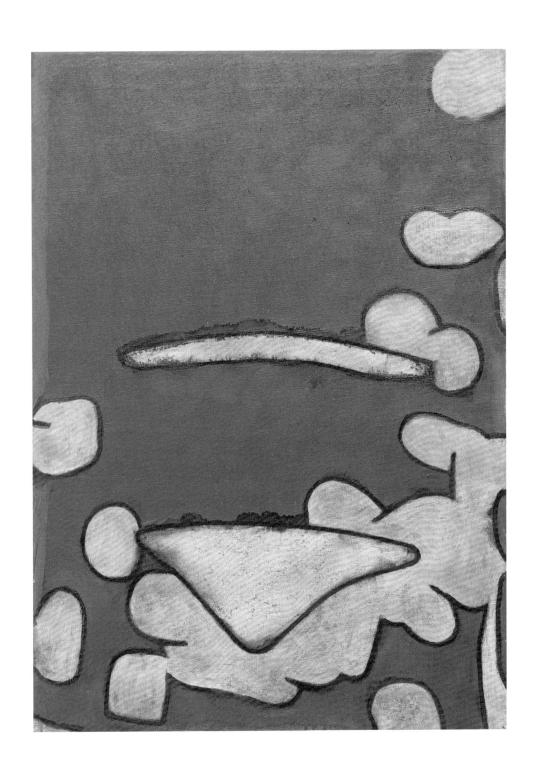

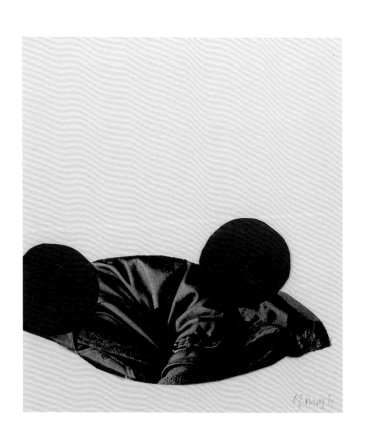

57 **Drapery Study** 1995
collage on card
16 x 14 cm

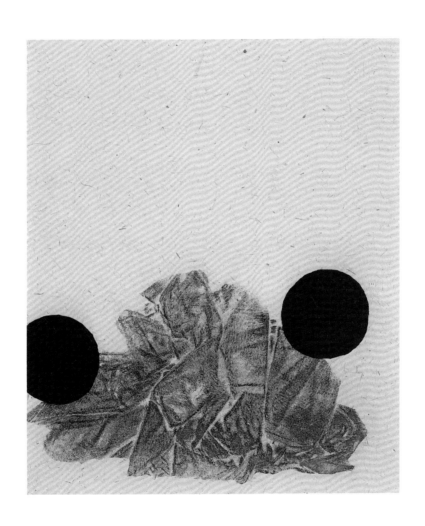

58 **Reflection** 1996
etching
28.5 x 24 cm

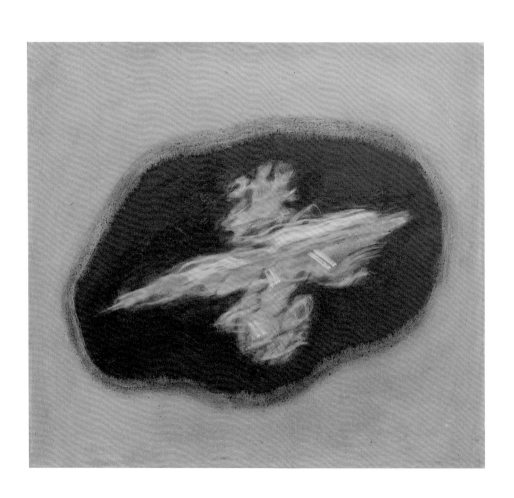

59 **Untitled** late 1990s
 oil on canvas
 45.7 x 51 cm

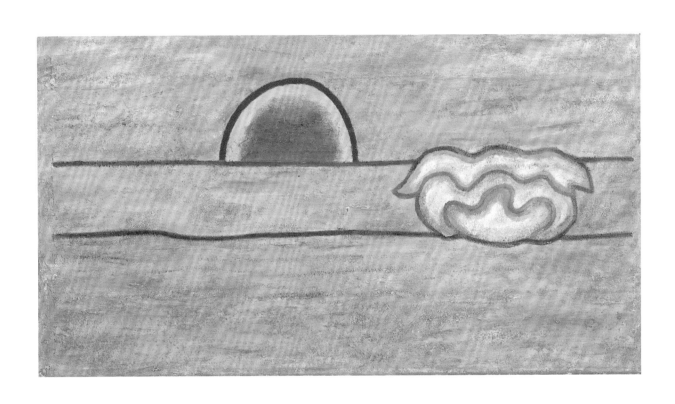

60 **Still Life** 1986/89
 oil on canvas
 41.7 x 76.2 cm

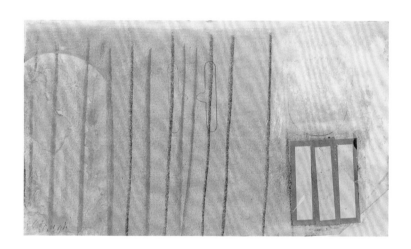

61 **Untitled** c.1980s
mixed media on paper
11 x 19.5 cm

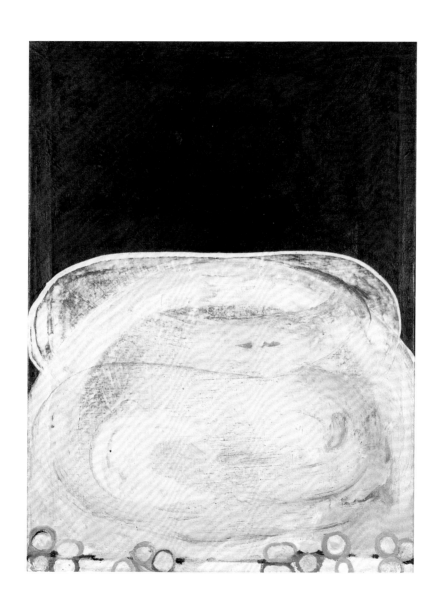

62 **Sweet Jar** 1992
 oil on canvas
 50 x 37.5 cm

63 **Trinket 2** 1996
 oil on canvas
 85 x 73 cm

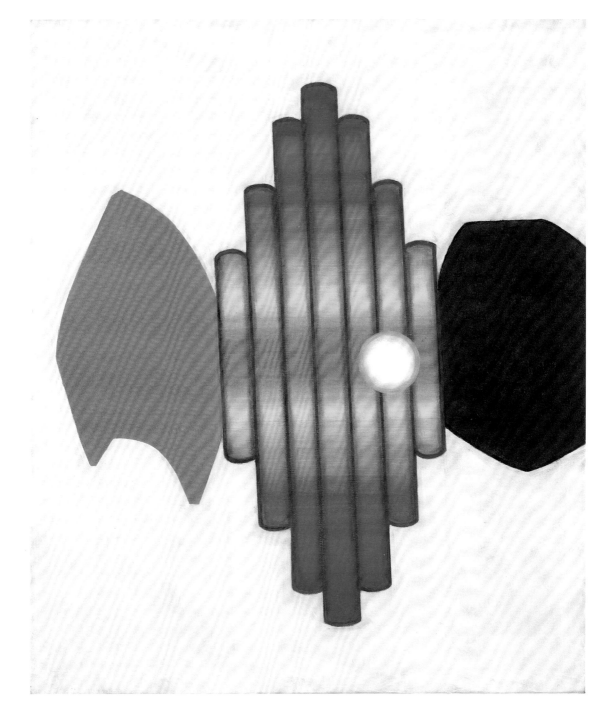

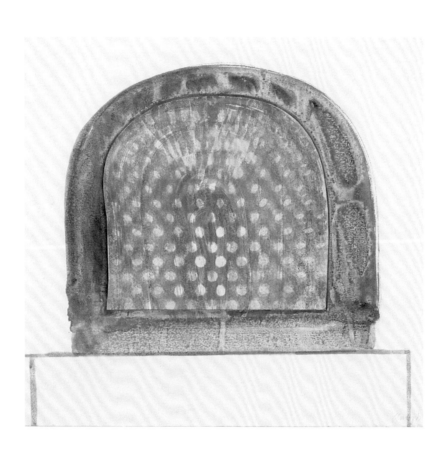

64 **Headstone** 1992
watercolour on paper
41 x 43.5 cm

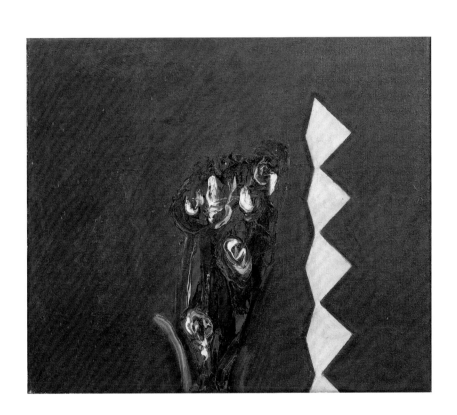

65 **Dark Flower** 1997
oil on canvas
30.5 x 35.5 cm

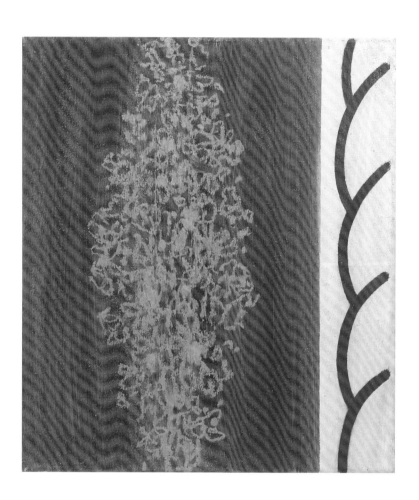

66 **Flower Head** 1997
oil on canvas
46 x 41 cm

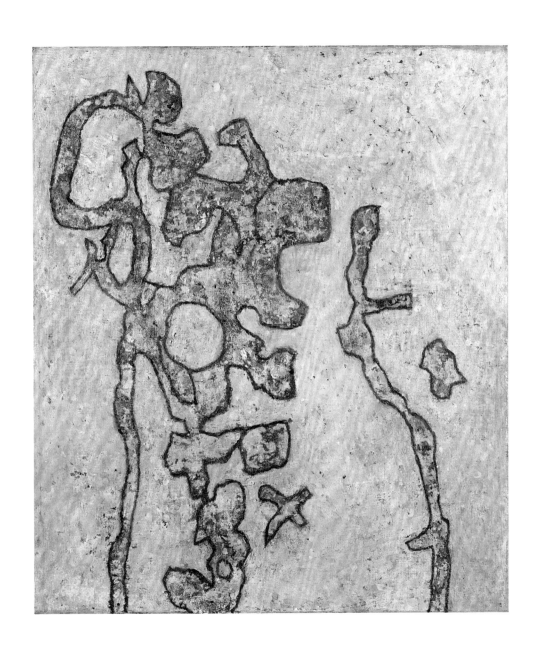

67 **Hedge** late 1990s
oil on canvas
61 x 53 cm

68 **Mesh with Glove I** 1980
oil on canvas
91 x 71 cm

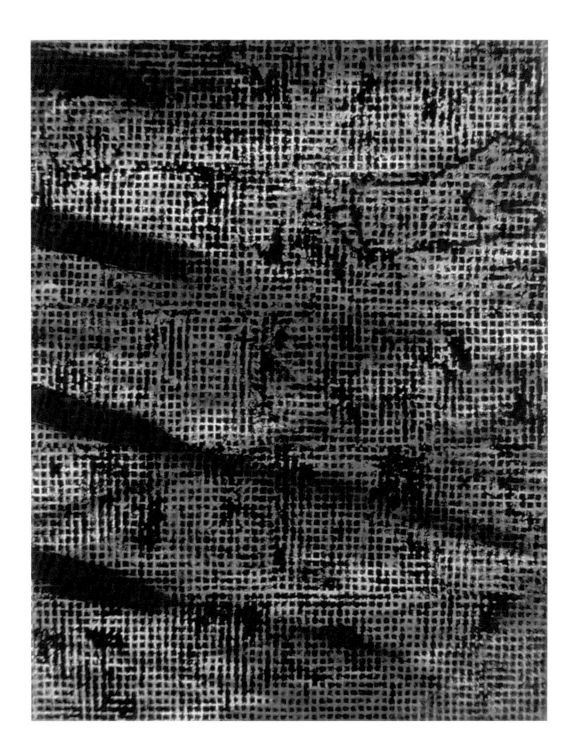

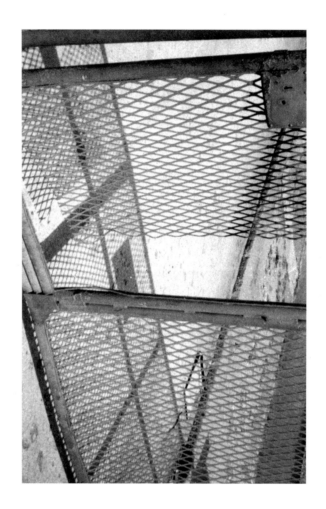

Source photograph

Biography

1919	Born in Chelsea, London. Her father worked for the Board of Trade and her aunt was the architect designer Eileen Gray.
1937	Attended Chelsea School of Art (part-time) where Henry Moore was a tutor. Studied design, life drawing and sculpture.
1939-1945	Worked in Office of War Information (USA) drawing charts and maps and working on magazine layouts.
1946-1949	Studied with Victor Pasmore at Camberwell School of Art (part-time). Visited various fishing ports in East Anglia including Lowestoft.
1950s	Was part of the group, which included Michael Ayrton, Keith Vaughan, John Craxton and the poet Dylan Thomas, that met in the Camden Hill Studio, which John Minton shared with Robert MacBryde and Robert Colquhoun. Work included in the 60 *Paintings for 1951 Festival of Britain* exhibition and the first São Paulo Biennale.
1956-1969	Taught part-time at Chelsea School of Art.
1966-1997	Taught part-time at Wimbledon School of Art.
1999	Awarded Jerwood Painting Prize.

Died 26 December 1999 in London.

One-Person Exhibitions

1947	Leger Galleries, London
1949	Roland, Browse & Delbanco, London
1953	Leicester Galleries, London
1960	Whitechapel Art Gallery, London, Arts Council exhibition touring to: City Art Gallery, York; College of Art, Bournemouth; Herbert Art Gallery, Coventry; Gracefield Arts Centre, Dumfries; Arts Council Gallery, Cambridge; Art Gallery, Blackburn; Art Gallery, Derby
1964	Grosvenor Gallery, London
1967	Bear Lane Gallery, Oxford
1968	Arnolfini Gallery, Bristol Grosvenor Gallery, London
1971	Hambledon Gallery, Blandford Forum New Art Centre, London Bear Lane Gallery, Oxford
1972	Graves Art Gallery, Sheffield
1973	New Art Centre, London
1975	New Art Centre, London Park Square Gallery, Leeds
1976	New Art Centre, London Scottish National Gallery of Modern Art, Edinburgh: touring to Serpentine Gallery, London
1979	New Art Centre, London
1981	Artspace, Aberdeen
1982	New Art Centre, London Fitzwilliam Museum, Cambridge Warwick Art Trust, London
1985	New Art Centre, London Imperial College Consort Gallery, London
1989	Annely Juda Fine Art, London
1992-1993	The Art Collection, Arthur Anderson, London
1993	Annely Juda Fine Art, London
1996	Camden Arts Centre, London; touring to Oriel 31, Newtown, Powys The Customs House Gallery, South Shields
1997-1998	Henie Onstad Kunstsenter, Høvikodden, Norway
1998	Annely Juda Fine Art, London
1999	Kettle's Yard, Cambridge: travelling to Graves Art Gallery, Sheffield

1999-2001 University of Essex, Colchester
Arts Council exhibition touring
to Peter Muni Arts Centre,
Pontypridd; Glynn Vivien Art
Gallery, Swansea; Peter Scott
Gallery, Lancaster; Ropewalk
Contemporary Art and Craft
Centre, Barton upon Humber;
Plymouth City Museum and Art
Gallery; Ruthin Gallery, Buckley
Library Gallery and Heritage
Centre; Denbigh Museum and
Art Gallery
Gainsborough's House, Sudbury
2000 Annely Juda Fine Art, London
2003 Annely Juda Fine Art, London
2007-2008 Tate Britain, London: touring to
Norwich Castle Museum & Art
Gallery, Norwich; Abbot Hall Art
Gallery, Kendal
2009 Annely Juda Fine Art, London

Selected Group Exhibitions

1945 *Summer Exhibition*, Redfern Gallery,
London
1946 *Summer Exhibition*, Redfern Gallery,
London
1947 *The London Group*, RBA Galleries,
London
Homestead Exhibition, Southwold
*Young British Artists: Selected by Bernard
Denvir*, Heal's Mansard Gallery,
London
Summer Exhibition, Redfern Gallery,
London
1948 *Nineteenth & Twentieth Century Women
Painters and Sculptors*, RBA Galleries,
London
Names to Remember, Roland, Browse
& Delbanco, London
Summer Exhibition, Redfern Gallery,
London
*Original colour prints by The Society of
London Painter-Printers*, Redfern
Gallery, London

1949 *Young Painters Working in Britain*,
A.I.A. Gallery, London
Summer Exhibition, Redfern Gallery,
London
Summer Exhibition, Gimpel Fils,
London
*Paintings and Drawings by London
Artists*, International House,
Edinburgh
*Original French and English Lithographs
and Monotypes*, Redfern Gallery,
London
1950 *Artists of Fame and Promise*, Roland
Browse & Delbanco, London
The London Group, New Burlington
Galleries, London
A Private Collection, York City Art
Gallery
Scènes de Ballet by Contemporary Artists,
Wildenstein, London
Painters Progress, Whitechapel Art
Gallery, London
Summer Exhibition, Redfern Gallery,
London
Summer Exhibition, RBA Galleries,
London
Artists of Fame and Promise, Leicester
Galleries, London
Summer Exhibition, Gimpel Fils,
London
Pittsburgh International, Carnegie
Institute, Pittsburgh
Twentieth Century British Painters,
Lefevre Gallery, London
*Cross Section of Drawings and
Watercolours*, Roland, Browse &
Delbanco, London
1950-1951 *1950: Aspects of British Art*, Institute
of Contemporary Art, London
French Paintings and Original Prints,
Redfern Gallery, London
1951 *New Year Exhibition*, Leicester
Galleries, London
Exhibition of Drawing, Redfern
Gallery, London
60 Paintings for '51, RBA Galleries,
London

First *Anthology of British Painting 1925–50*, organised by the Arts Council, London and Manchester
I Bienal, Museo de Arte Moderne, São Paulo
Young Contemporaries, RBA Galleries, London
Patrick Heron, Humphrey Spender, Fred Uhlman, Graham Sutherland, Keith Vaughan, Marek Zulawski, Prunella Clough, Reginald Weston, Redfern Gallery, London
French and English original colour lithographs, Redfern Gallery, London
British Painting, New Burlington Galleries, London
Artists of Fame and Promise, Leicester Galleries, London

1952 *Four Contemporaries*, Heffer's Gallery, Cambridge
Artists of Fame and Promise, Leicester Galleries, London
Summer Exhibition, Redfern Gallery, London
Summer Exhibition, Roland, Browse & Delbanco, London
Looking forward: an exhibition of realist pictures by contemporary British artists, Whitechapel Art Gallery, London
Contemporary French and English lithographs, Redfern Gallery, London

1953 *New Year Exhibition*, Leicester Galleries, London
Contemporary French and English lithographs, Redfern Gallery, London
Colour prints, A.I.A. Gallery, London
Exhibition of contemporary British paintings, Redfern Gallery, London
Pictures to be enjoyed, A.I.A. Gallery, London
This England, Art Gallery, Battersea Park, London
Coronation Exhibition, Redfern Gallery, London

The renaissance of the fish: paintings from the 17th to the 20th century, Roland, Browse & Delbanco, London
London Group Show, New Burlington Galleries, London

1954 *New Year Exhibition*, Leicester Galleries, London
Life in Industry, Management House, London (organised by the Artists International Association)
Paintings, drawings, prints from the movements of Cubism, Abstractionism, Surrealism, Formalism, Redfern Gallery, London
Figures in their setting, Contemporary Art Society exhibition, Tate Gallery, London
Summer Exhibition, Redfern Gallery, London
British Painting and Sculpture, Whitechapel Art Gallery, London
Artists of fame and promise, Leicester Galleries, London
Autumn Exhibition, A.I.A. Gallery, London

1955 *Sea: Pictures for Schools*, Whitechapel Art Gallery, London
Measurement and Proportion, A.I.A. Gallery, London
Summer Exhibition, Redfern Gallery, London
Artists of Fame and Promise, Leicester Galleries, London
Contemporary trends, A.I.A Gallery, London

1956 *Vision and Reality*, Wakefield City Art Gallery
Summer Exhibition, Redfern Gallery, London
Artists of Fame and Promise, Leicester Galleries, London
IV Mostra Internazionale di Bianco e Nero, Lugano

1957 A.I.A. Gallery, exhibition with Adrian Heath, London
Summer Exhibition, Redfern Gallery, London

1958	*AIA 25: An exhibition to celebrate the twenty-fifth anniversary of the foundation in 1933 of the Artists International Association*, RBA Galleries, London
1960	*The Guggenheim Foundation International Award*, RWS Galleries, London
1961	*Figures in Landscape*, Bear Lane Gallery, London
	Christmas present exhibition: small pictures by English and French artists, Roland, Browse & Delbanco, London
1963	*Prints*, Bear Lane Gallery, London
1964	*British Contemporary Artists: Reg Butler, Prunella Clough, Terry Frost, Patrick George, Robert Medley, Claude Rogers, William Townsend, Bryan Wynter*, New Metropole Arts Centre, Folkestone
	First Image, Grosvenor Gallery, London
1965	*Peter Stuyvesant Foundation: 1965 purchases*, Whitechapel Art Gallery, London
	Loan exhibition of modern pictures from the Bernstein and Granada Collections, Whitworth Art Gallery, Manchester
	Prunella Clough, Tom Nash, Italo Valentini, Keith Vaughan, Clare Hall Gallery, Cambridge
	Impressions on paper, Arnolfini Gallery, Bristol
	Hambledon Gallery, Blandford
	Christmas present exhibition, Roland, Browse & Delbanco, London
1966	The Whitworth Art Gallery, Manchester
	Museum of Modern Art, Oxford
1967	*Recent British Painting: Peter Stuyvesant Foundation Collection*, Tate Gallery, London
1967-1968	*British sculpture and painting from the collection of the Leicestershire Education Authority*, Whitechapel Art Gallery, London: toured to UCLA Art Galleries, Los Angeles
1968	*British Prints in the Sixties*, Arnolfini Gallery, Bristol
	The Frederick Wright Gallery, UCLA, Berkeley, California
1969	Tib Lane Gallery, Manchester
1970	*British Drawings 1952-1972*, Angela Flowers, London
	Multiples, New Art Centre, London
1971	Bear Lane Gallery, Oxford
1972	*Decade '40s: painting, sculpture and drawings in Britain 1940-49*, Whitechapel Art Gallery, London (and touring) Bruton Gallery, Somerset
1974	*Critic's Choice: 1974 selection by Marina Vaizey*, Arthur Tooth & Sons, London
	Desborough Gallery, Perth
	British Painting, Hayward Gallery, London
1975	*Prunella Clough, Adrian Heath, Jack Smith, Franciszka Themerson*, Sunderland Arts Centre, Sunderland
	Eton College
	Park Square Gallery, Leeds
	Small is Beautiful, Angela Flowers, London
1976	*Collage*, Angela Flowers Gallery, London
1977	*Artists at Curwen: A celebration of the gift of artist's prints from the Curwen Studio*, Tate Gallery, London
	Monika Kinley, London
	Peter Millard, Saskatoon, Canada
	British Art 1952-1977, Royal Academy, London
1978	Liverpool Academy of Art
1979	*Seven British Painters 1944-78*, Consort Gallery, Imperial College, London
1981	Artspace Galleries, Aberdeen
1982-1983	Ikon Gallery, Birmingham and tour
1984	*The Forgotten Fifties*, Graves Art Gallery, Sheffield: touring to Norwich Castle Museum & Art

1985 — Gallery, Norwich; Herbert Art Gallery and Museum, Coventry; Camden Arts Centre, London; Studio ODD, Hiroshima

1985 *Real and Abstract: an exhibition of paintings, drawings, sculpture, graphics*, Redfern Art Gallery, London
Black and White: An exhibition of paintings, drawings and prints by Chris Baker, Prunella Clough, Jane Joseph, Michael Murfin, Consort Gallery, Imperial College, London

1986 *Art, Science & Industry: An exhibition for Industry Year*, Consort Gallery, Imperial College, London

1987 *Small is Beautiful part 5: Landscapes*, Angela Flowers Gallery, London

1988 *– moments of being –* , South Bank Centre, London
Nine Neo-Romantic Artists: Nash, Piper, Sutherland, Ayrton, Clough, Colquhoun, Craxton, Minton, Vaughan, Albemarle Gallery, London
The Print Show, Angela Flowers Gallery, London
A selection of Post-War British Abstract Art, Austin/Desmond Fine Art, London

1989 *Monoprints*, Flowers East, London
The Abstract Connection, Flowers East, London

1990 *Avant-garde British Printmaking 1914–1960*, British Museum, London
The Abstract Print Show, Flowers East, London
Contemporary Graphics, Curwen Gallery, London
Modern British Paintings, Austin/ Desmond Fine Art, London
Exhibition of Modern Paintings, Jonathan Clark, London

1991 *The Discerning Eye*, The Mall Galleries, London and tour

1992 *Drawing from the Imagination*, Morley Gallery, London

The Poetic Trace: Aspects of British Abstraction, Adelson Galleries, New York
The Discerning Eye, Mall Galleries, London

1993 *New Beginnings. Postwar British Art from the Collection of Ken Powell*, Scottish National Gallery of Modern Art, Edinburgh: touring to Sheffield and London

1994 *The Print Show 1993*, Flowers Graphics, London
Etching, Flowers Graphics, London
British Abstraction, Flowers East, London

1995 *British Abstract Art Part I: Paintings*, Flowers East at London Fields, London
1945: The End of the War, Annely Juda Fine Art, London
An exhibition of monotypes: Basil Beattie, Prunella Clough, Alan Cox, Alan Cox, Kevin O'Brien, Art Space Gallery, London
Flowers Graphics: Contemporary Print Publishers, Flowers East, London

1995-1996 *Natural Forces*, Reed's Wharf Gallery, London

1996 *British Abstract Art Part 3: Works on Paper*, Flowers East at London Fields, London
The Print Show 1996, Flowers Graphics, London
Post War British Prints: Catalogue Two, Austin/Desmond Fine Art, London

1997 Aldeburgh Festival 50th Anniversary
Print, Riverside Studios, London
The Print Show 1997, Flowers Graphics, London
Prints and Monoprints by Boyd & Evans, Stephen Chambers, Prunella Clough [et.al.], Flowers East, London
Prunella Clough: David Carr: Works 1945–1964, Austin/Desmond Fine Art, London

Tenth Anniversary Portfolio: Peter Blake, Patrick Caulfield, Prunella Clough, Susan Hiller, Mathew Hilton, Joseph Kosuth, Claes Oldenburgh, Cornelia Parker, Alison Watt, Paul Wunderlich, Freud Museum, London

1997-1998 Aspects of Modern British and Irish Painting, Austin/Desmond Fine Art, London

1998 The Print Show 1998, Flowers Graphics, London
The Fifties: Art from the British Council Touring Collection, British Council London (and touring)
Forty Years at Curwen Studio 1958-1998: an exhibition held at Curwen Gallery and the New Academy Gallery to mark the Studio's fortieth anniversary, Curwen Gallery, London
Etchings from Hope, Sufferance, Marlborough Graphics, London
Aspects of Modern British Art 1910–1965, Austin/Desmond Fine Art, London

1999 New Prints and Publications, Flowers Graphics, London
Contemporary British Landscape, Flowers East, London
The Print Show 1999, Flowers Graphics, London
White Out, Gallery Fine, London
Jerwood Painting Prize 1999, Jerwood Gallery, London

1999-2000 '45-99: A Personal View of British Painting and Sculpture by Bryan Robertson, Kettle's Yard, Cambridge
Aspects of Modern British and Irish Art, Austin/Desmond Fine Art, London

2001 Arts Works: British and German Contemporary Art 1960-2000, Deutsche Bank Collection

2002 Transition: The London Art Scene in the Fifties, Barbican Art Gallery, London
Twentieth Century British Printmaking: from William Nicholson to Howard Hodgkin, Austin/Desmond Fine Art, London

Aspects of Modern British and Irish Art, Austin/Desmond Fine Art, London

2003 Aspects of Modern British Art: Paintings, Graphics and Ceramics, Austin/Desmond Fine Art, London
Aspects of Modern British and Irish Art, Austin/Desmond Fine Art, London

2004 Aspects of Modern British and Irish Art, Austin/Desmond Fine Art, London

2005 The Twentieth Century: Paintings, Works on Paper, Sculpture, Furniture & Decorative Arts, Fine Art Society, London
20th-Century British Art: Painting, Sculpture, Drawings, Prints, Osborne Samuel, London

2006 Prints 2006: Modern British, International, Contemporary, Osborne Samuel, London

2007 Annely Juda - A Celebration, Annely Juda Fine Art, London

Selected Public Collections

Aberdeen Art Gallery
Belfast City Art Gallery
Birmingham Museum and Art Gallery
Bolton Museum and Art Gallery
Art Gallery of Greater Victoria, British Columbia
Bristol Museum and Art Gallery
Cambridge Arts Trust
Clare College, Cambridge
Herbert Museum and Art Gallery, Coventry
Derbyshire Education Committee
Derbyshire County Council
Devon Education Authority
The Irish Museum of Modern Art, Dublin
Eccles City Art Gallery
Scottish National Gallery of Art, Edinburgh
Hallmark Art Collection, Kansas City
Leeds Art Gallery
Leicestershire Education Authority
Walker Art Gallery, Liverpool

Arts Council of Great Britain, London
British Council, London
British Museum, London
Contemporary Art Society, London
The Financial Times, London
Government Art Collection, London
Tate Gallery, London
Victoria and Albert Museum, London
N.W. Arts Trust, Londonderry
East Midland Arts, Loughborough
Manchester City Art Gallery
Whitworth Art Gallery, Manchester
Museum of Modern Art, New York
Norwich Contemporary Art Society
Nottingham Education Committee
Nuffield Foundation
Oldham Art Gallery
Exeter College, Oxford
Pembroke College, Oxford
Plymouth City Museum and Art Gallery
Poole Education Committee
Portsmouth City Museum
Rugby City Libraries
Museo de la Solidad Salvator Allende, Santiago
Sheffield City Art Gallery
Sunderland Museum and Art Gallery
Art Gallery of New South Wales, Sydney
Toledo Art Museum, Ohio
Graphische Sammlung Albertina, Vienna
Wakefield City Art Gallery
West Riding of Yorkshire Education
Committee

Selected Bibliography

Mary Chamot, Dennis Farr and Martin Bultin, *The modern British paintings, drawings and sculptures*, Oldbourne Press, London, 1964, vol. 1, pp. 110-111

Bryan Robertson, John Russell and Lord Snowdon, *Private View*, Thomas Nelson, London, 1965, pp. 124-25

Arts Council Collection: a concise, illustrated catalogue of paintings, drawings, photographs and sculpture purchased for the Arts Council of Great Britain between 1942 and 1978, Arts Council of Great Britain, London, 1979, p. 65

Robert Hewison, *In Anger: Culture in the Cold War 1945–1960*, Weidenfeld & Nicholson, London 1981, p. 125

The British Council Collection 1934-1984, British Council, London 1984, p. 49

Francis Spalding, *British Art Since 1900*, Thames and Hudson, London, 1986, pp. 152-3

The Tate Gallery 1982-84: Illustrated Catalogue of Acquisitions, Tate Gallery, London, 1986, pp. 125-6

Jorge Lewinski, *Portrait of the Artist: 25 Years of British Art*, Carcanet Press, London, 1987, pp. 46-7

Malcolm Yorke, *The Spirit of Place: Nine Neo-Romantic Artists and their Times*, Constable, London, 1988, pp. 285-99

Arts Council Collection: Acquisitions 1984-88, Arts Council of Great Britain, London 1989, p. 24

The British Council Collection 1984-1994, British Council, 1995

Sandra Penketh (ed.), *Concise illustrated catalogue of British Painting in the Walker Art Gallery and at Sudley*, National Museums & Galleries on Merseyside, Liverpool, 1995, pp. 58-9

Peter Woodcock, 'Nature Unbound. The Work of Prunella Clough', in *This Enchanted Isle. The Neo-Romantic Vision from William Blake to the New Visionaries*, Gothic Image Publications, Glastonbury 2000, pp. 48-9

James Hyman, *The Battle for Realism: Figurative Art in Britain during the Cold War 1945-1960*, Yale University Press (for the Paul Mellon Centre for Studies in British Art), London, 2001, pp. 74-5

Martin Harrison, *Transition: The London Art Scene in the Fifties*, Merrell, London, 2002, pp. 78, 179

Arts Council Collection: Acquisitions 1989-2002, Arts Council Collection, 2003, pp. 47-9

Caroline Cuthbert, Richard Stone and Lesley Payne, *Barclays Art Collection*, Barclays, London 2003, pp. 142-7

Alicia Foster, *Tate Women Artists*, Tate Publishing, London 2004

Oil Paintings in Public Ownership in West Yorkshire: Leeds, The Public Catalogue Foundation, London, 2004

ISBN 1-904621-30-9

Printed by BAS Printers Ltd, England